SAFETY FIRST

COLORING BOOK

Cathy Beylon

DOVER PUBLICATIONS, INC.
Mineola, New York

MW00934652

Note

Every day, you make choices: Will you have pancakes or eggs for breakfast? Should you wear a red shirt or a blue one? These are "small" choices. But you also make "big" choices: Is it safe to cross the street? Should you pet a cute dog you've never seen before? What should you do if you hear thunder at the beach?

In this book, you will learn all about making safe "big" choices. Each page has a picture of something that could happen, in places such as your own home, the playground, the beach or pool, and the streets and roads where you live. A sentence or two tells you what the best choice is in each place.

You can talk about the choices with an adult you trust—your parent or the person who takes care of you, an older sister or brother, a family friend, or a teacher. Putting "safety first" means making the choice that is the safest for you, your family, and your friends.

After you have read each page, you can color in the pictures. Use crayons, markers, or colored pencils and color the pages any way you wish. It's a good idea to read this book over and over—this will help you to know what to do. And remember: You can always make a choice to put "safety first"!

Copyright

Copyright © 2006 by Cathy Beylon
All rights reserved.

Bibliographical Note

Safety First Coloring Book is a new work, first published by Dover Publications, Inc., in 2006.

DOVER *Pictorial Archive* SERIES

This book belongs to the Dover Pictorial Archive Series. You may use the designs and illustrations for graphics and crafts applications, free and without special permission, provided that you include no more than four in the same publication or project. (For permission for additional use, please write to Permissions Department, Dover Publications, Inc., 31 East 2nd Street, Mineola, N.Y. 11501.)

However, republication or reproduction of any illustration by any other graphic service, whether it be in a book or in any other design resource, is strictly prohibited.

International Standard Book Number: 0-486-45164-X

Manufactured in the United States of America
Dover Publications, Inc., 31 East 2nd Street, Mineola, N.Y. 11501

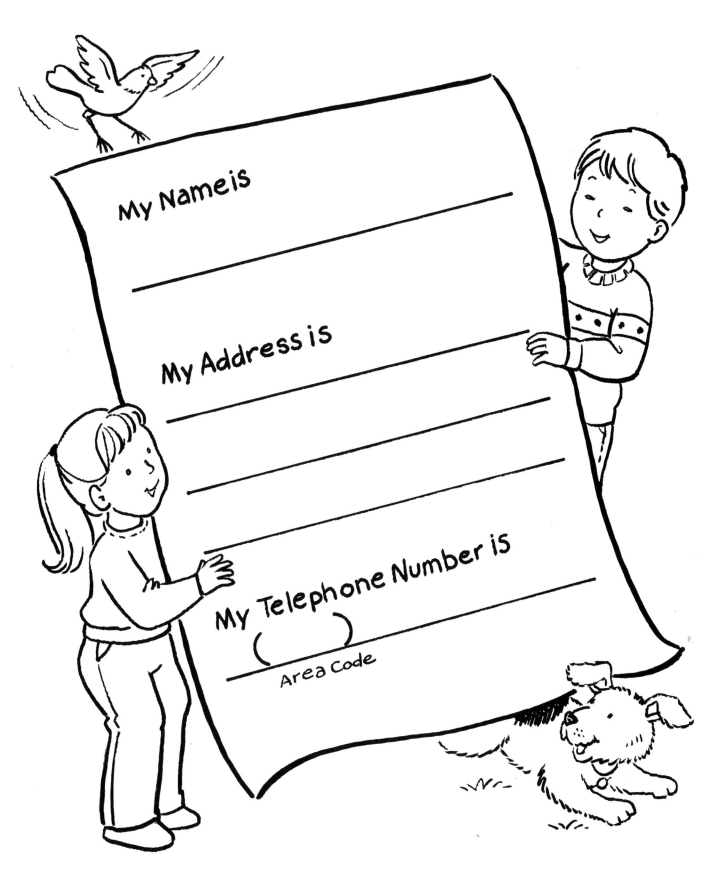

My Name is

My Address is

My Telephone Number is

()

Area Code

Everyone should know these important things—
Your full name, your address, and
your home telephone number.

1

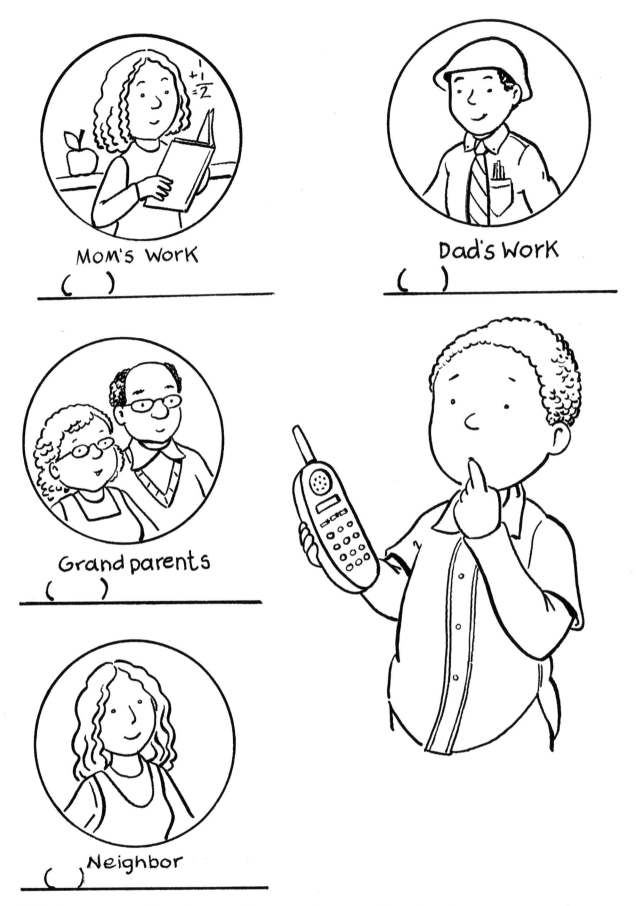

Mom's Work
()

Dad's Work
()

Grandparents
()

Neighbor
()

Make sure that you know important phone numbers.
If you have a cell phone, learn that number, too.

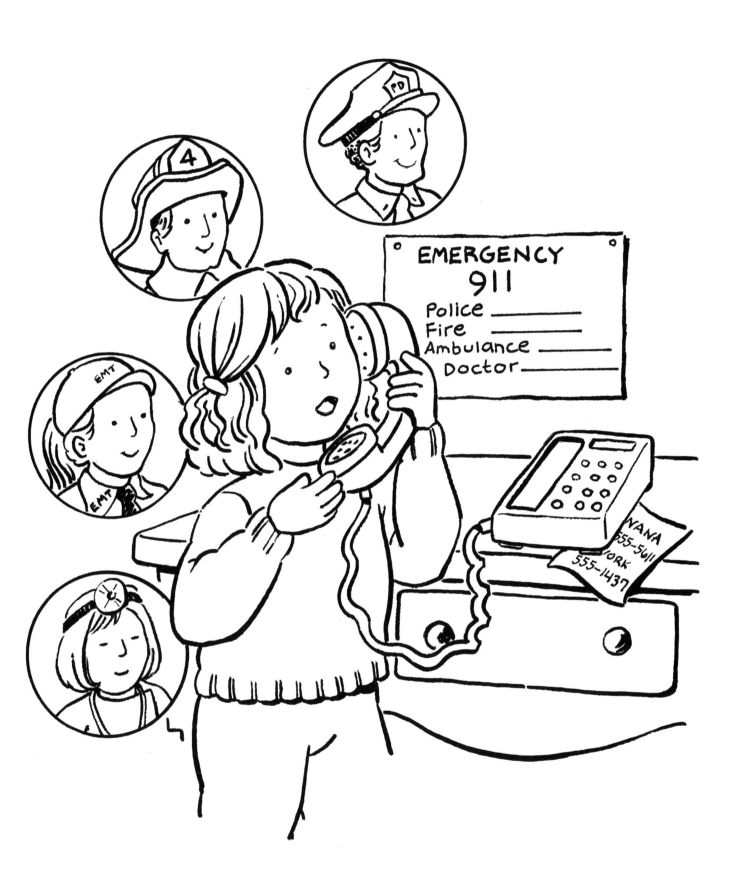

Call 911 in an emergency.
Be ready to say where you live and what the problem is.

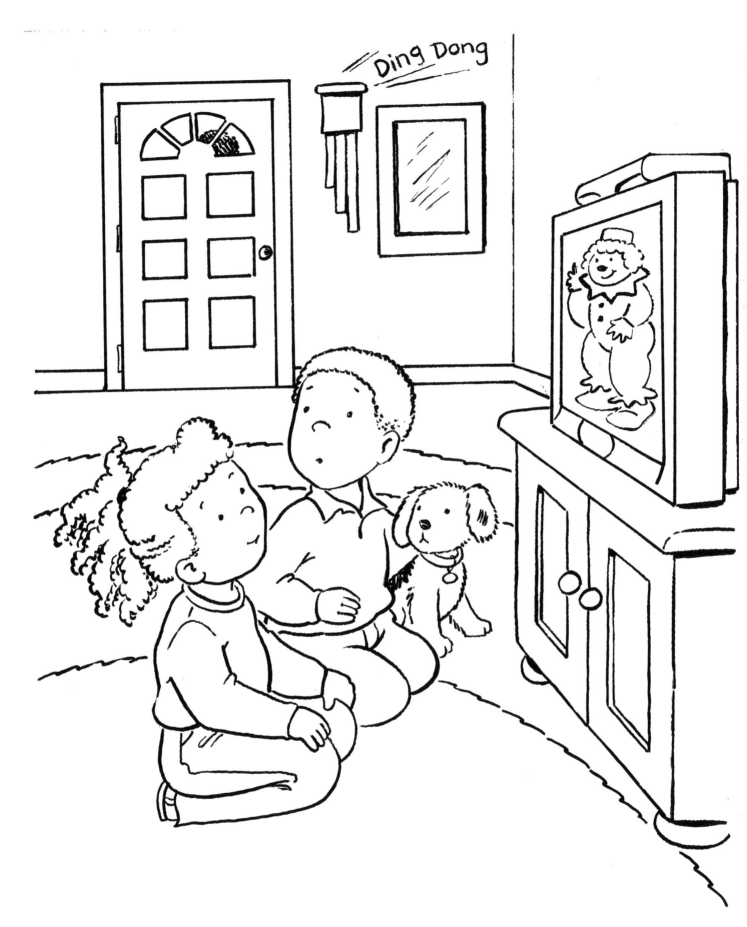

Never open the door to strangers.

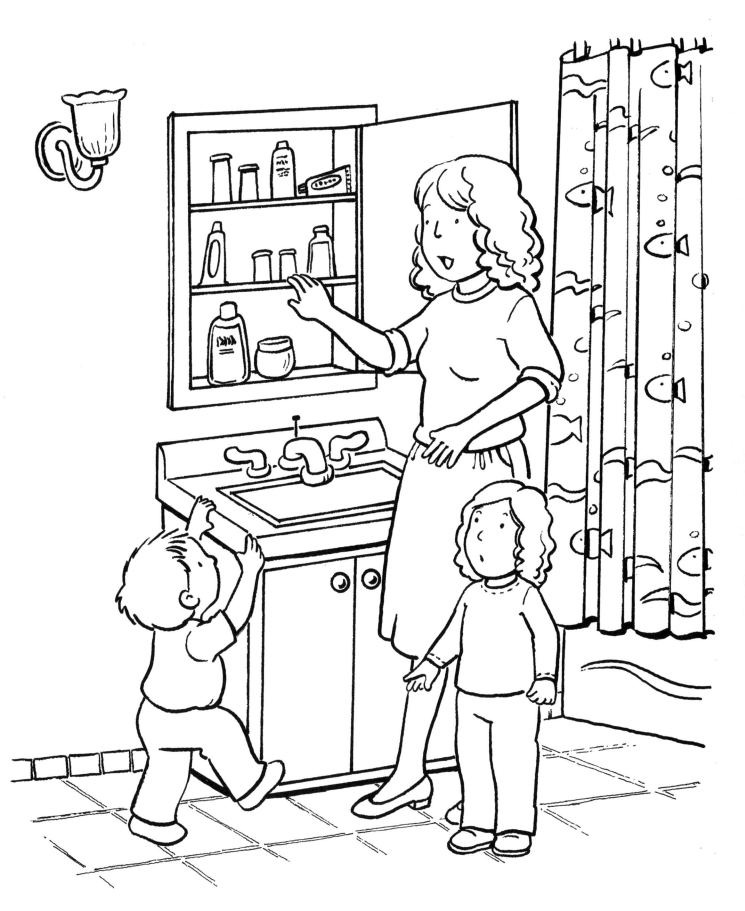

Never take medicine unless your parents
or doctor gives it to you.

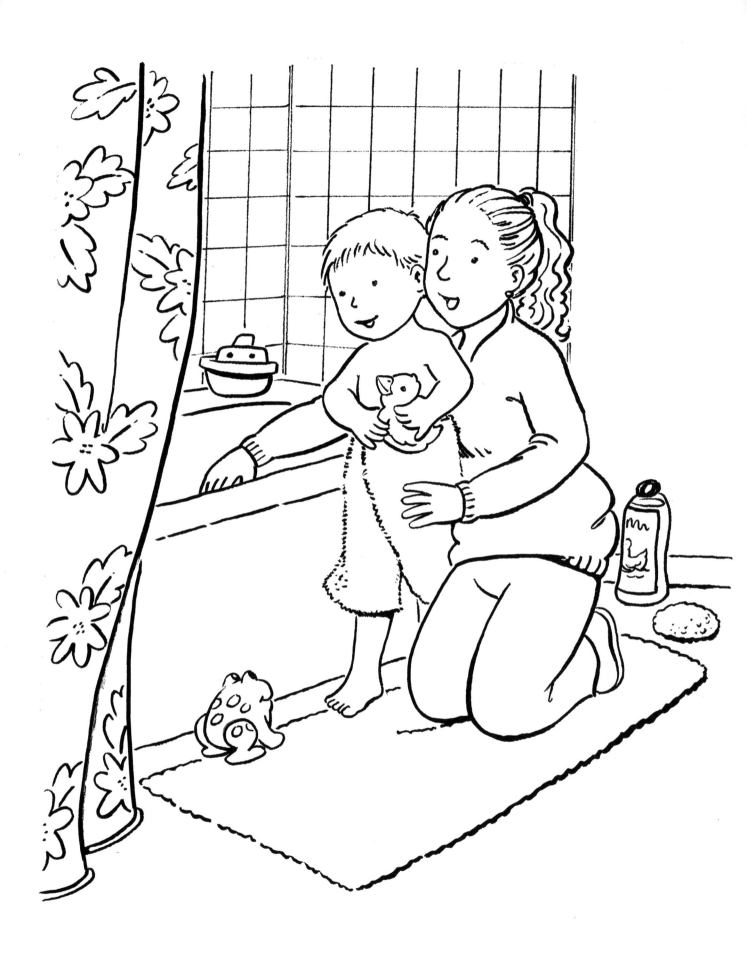

Always test hot water first to be safe.

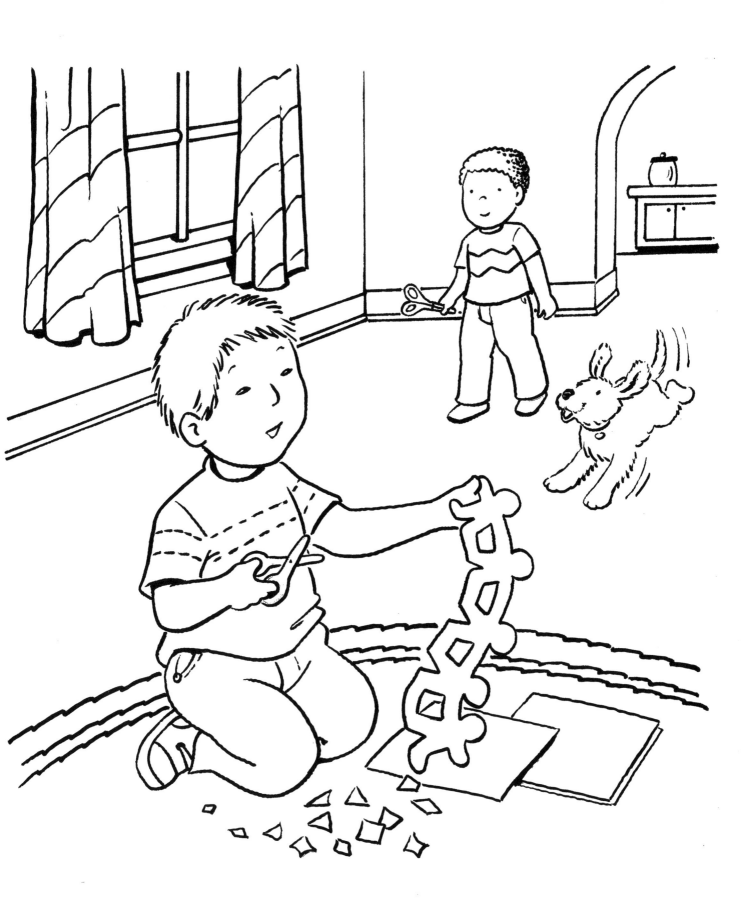

Learn how to hold scissors.
Never run with scissors in your hands.

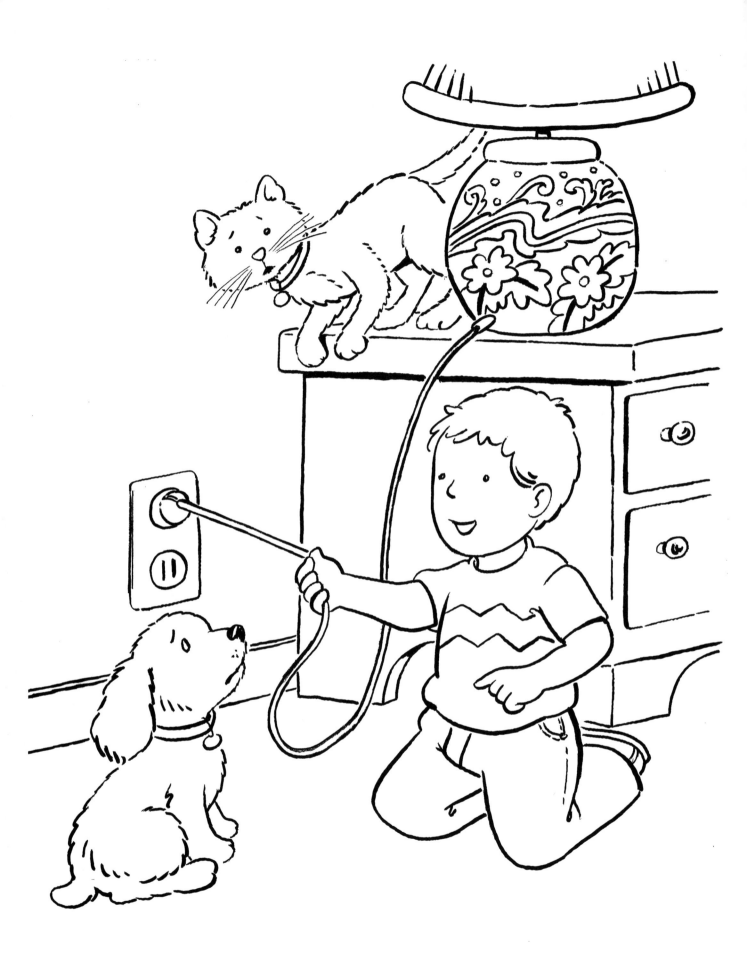

Don't play with wall plugs.

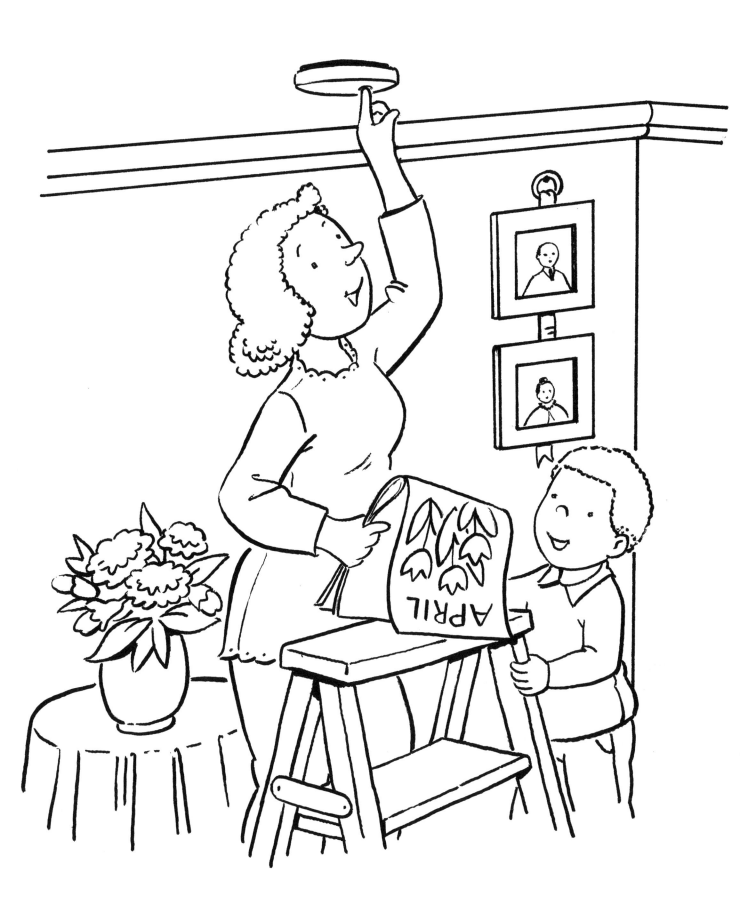

Remind your parent to test the smoke alarm
twice a year.

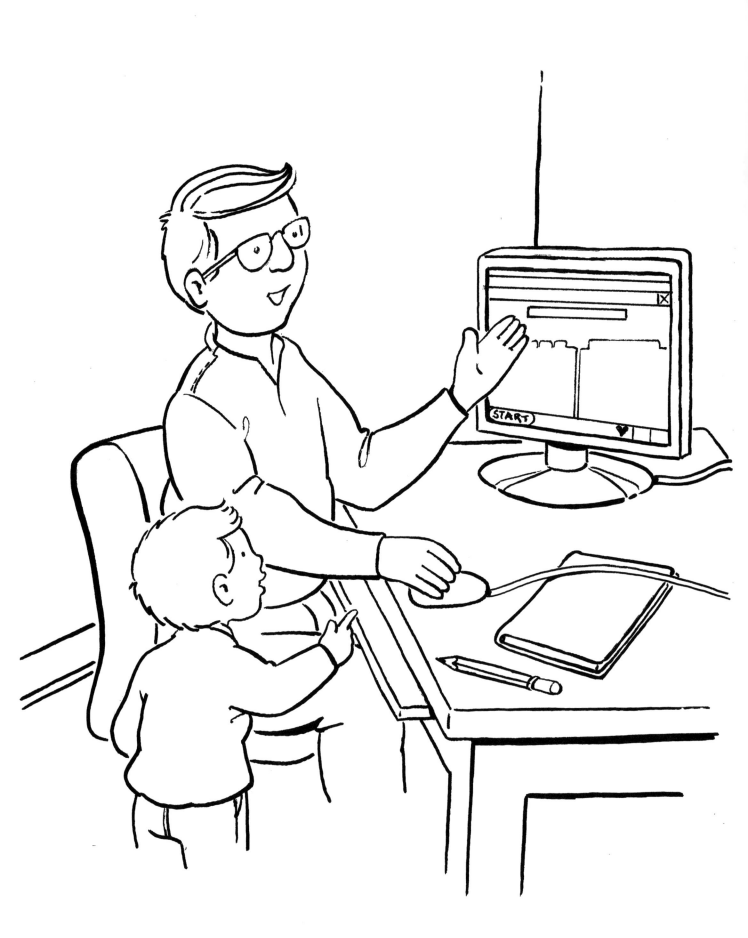

If you use a computer, never tell anyone personal things.

Never play with matches.

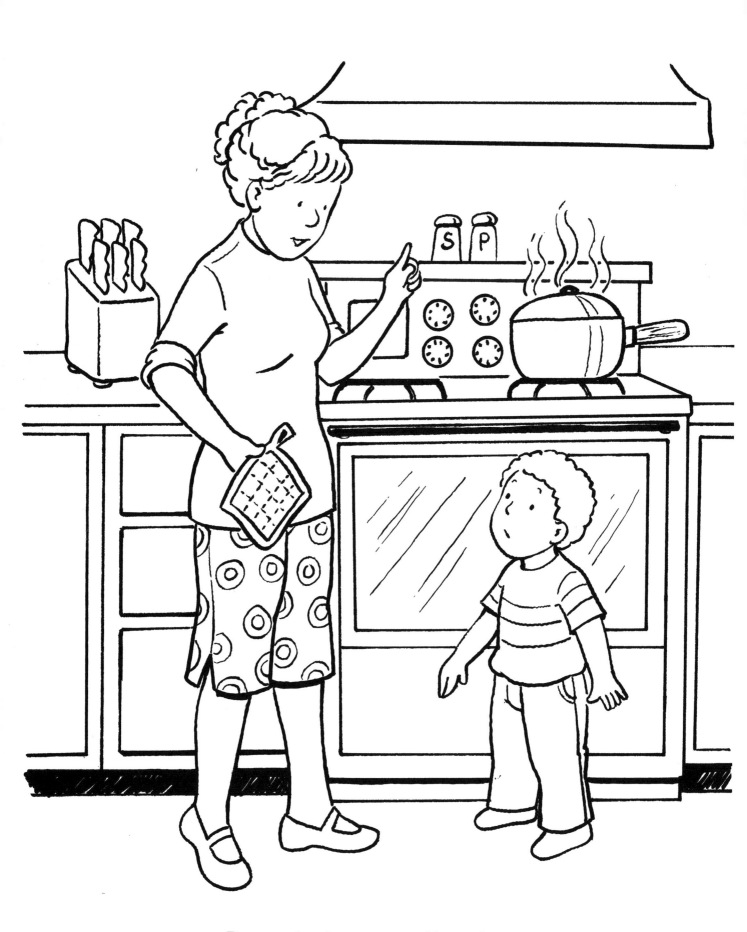

Do not play near the stove,
and never play *with* the stove.

Make sure that your family has an escape plan
in case of a fire. Know what these plans are!

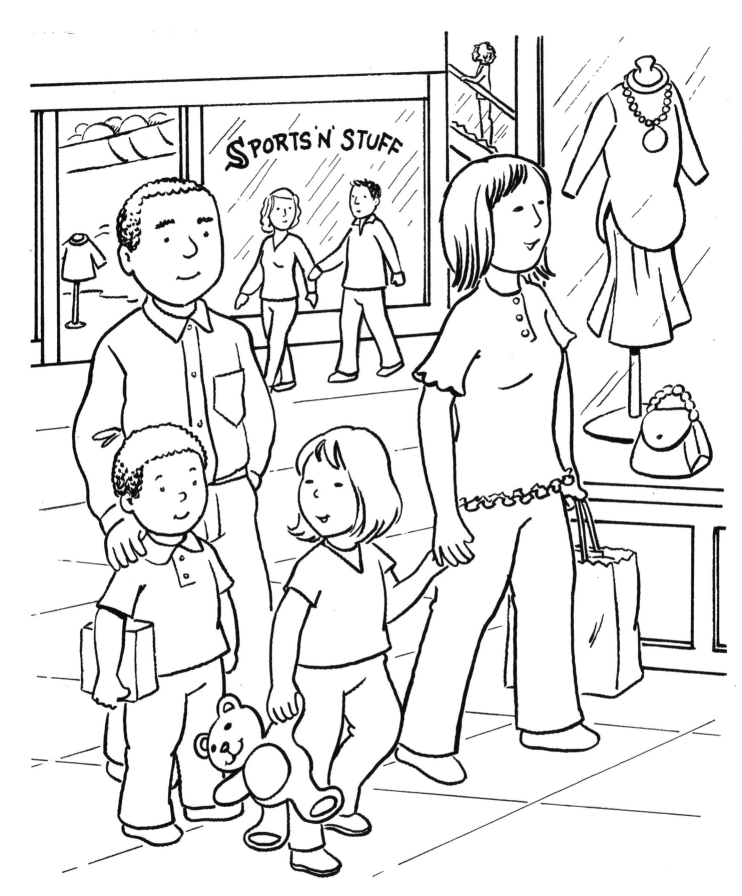

Always stay near your parents or the person who takes care of you when you are out shopping.

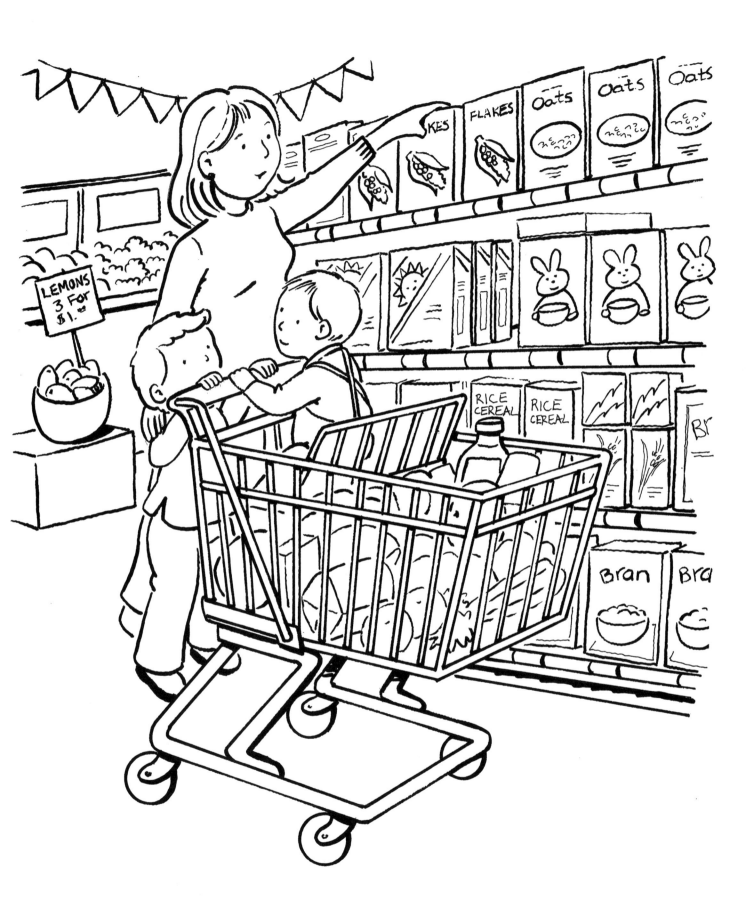

Always stay seated if you are riding in a shopping cart.
Make sure that your younger brother or sister stays seated.

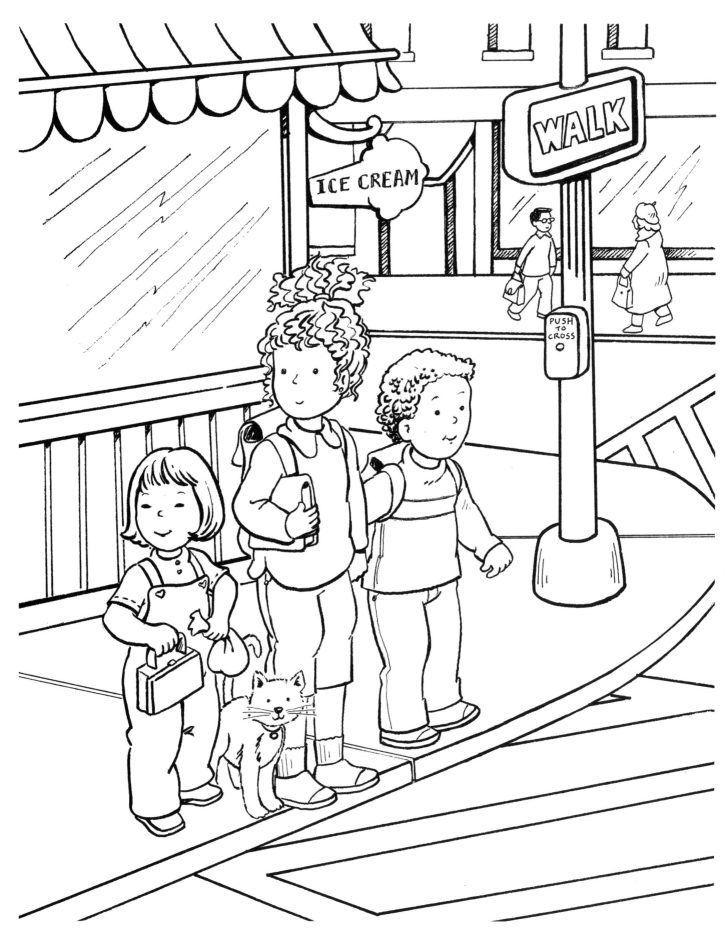

Always cross the street where it is safe—
usually there are lines or signs to follow.

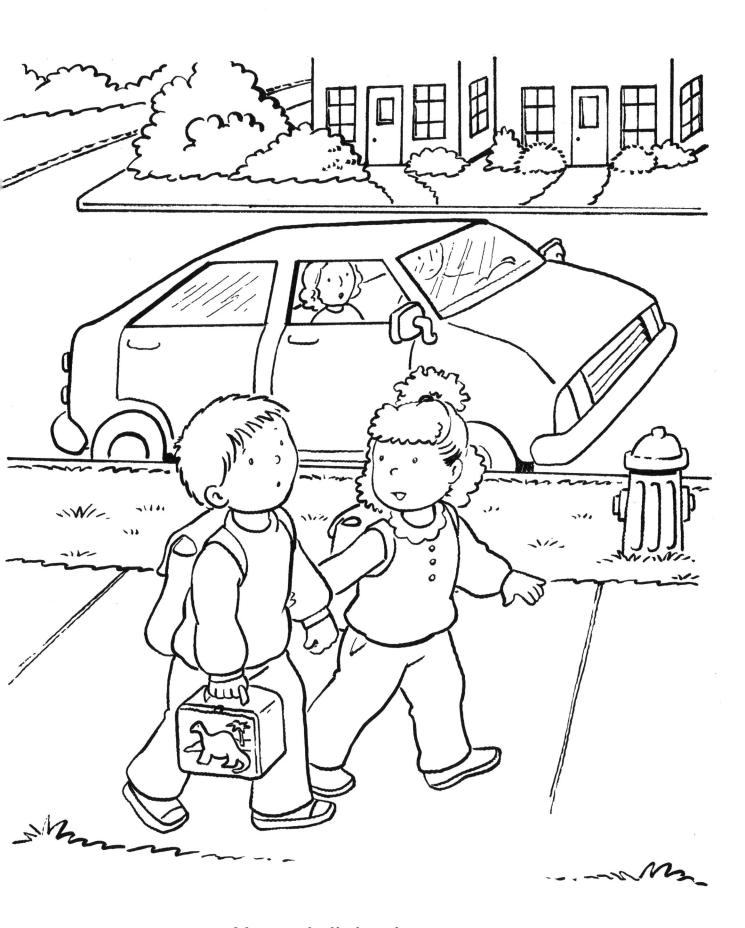

Never talk to strangers.
Ignore them and keep walking, or run away.

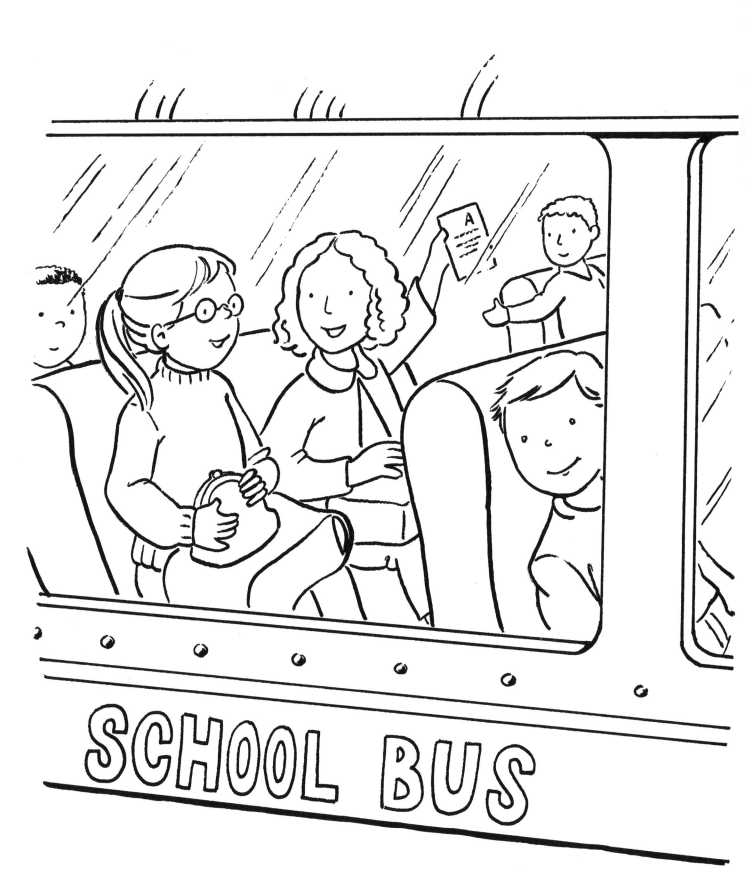

Always stay in your seat on the school bus.
Wait until it comes to a full stop.

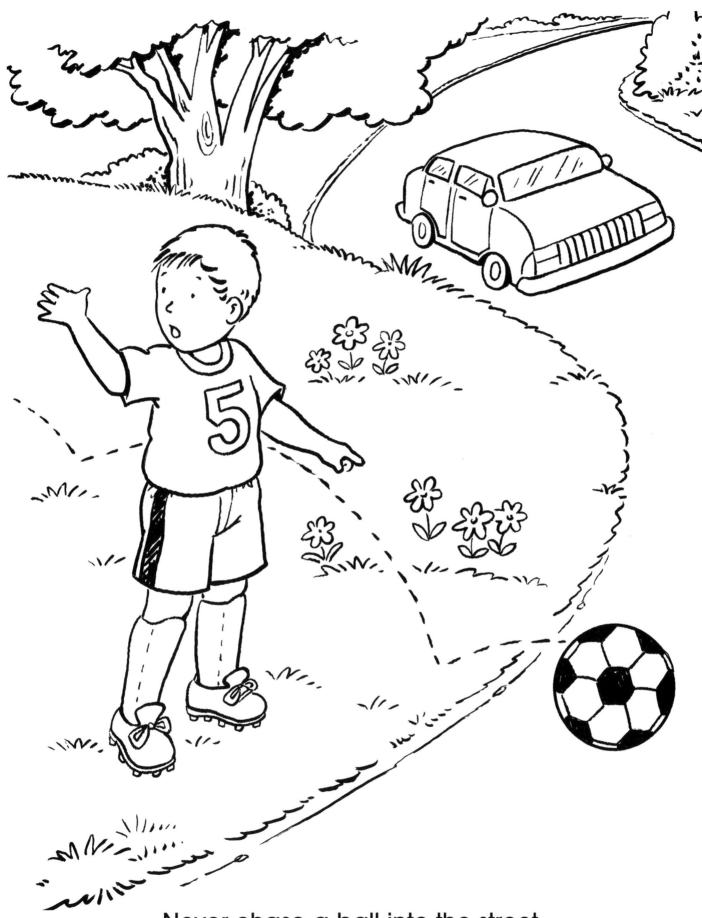

Never chase a ball into the street.
Wait until it is safe to cross.

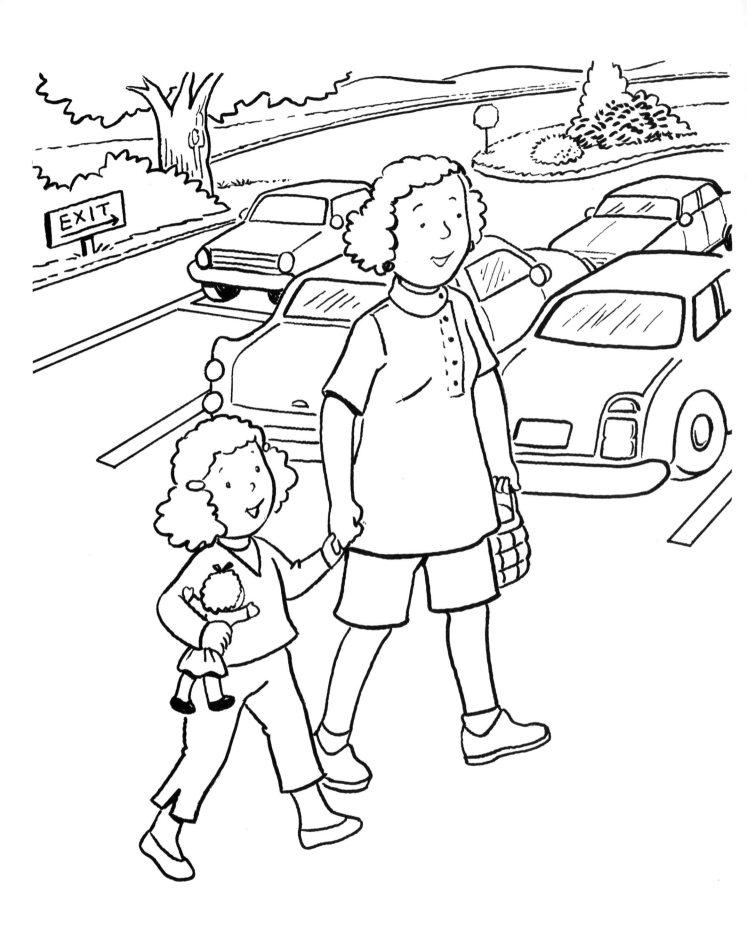

Always hold an adult's hand
when you walk in a parking lot.

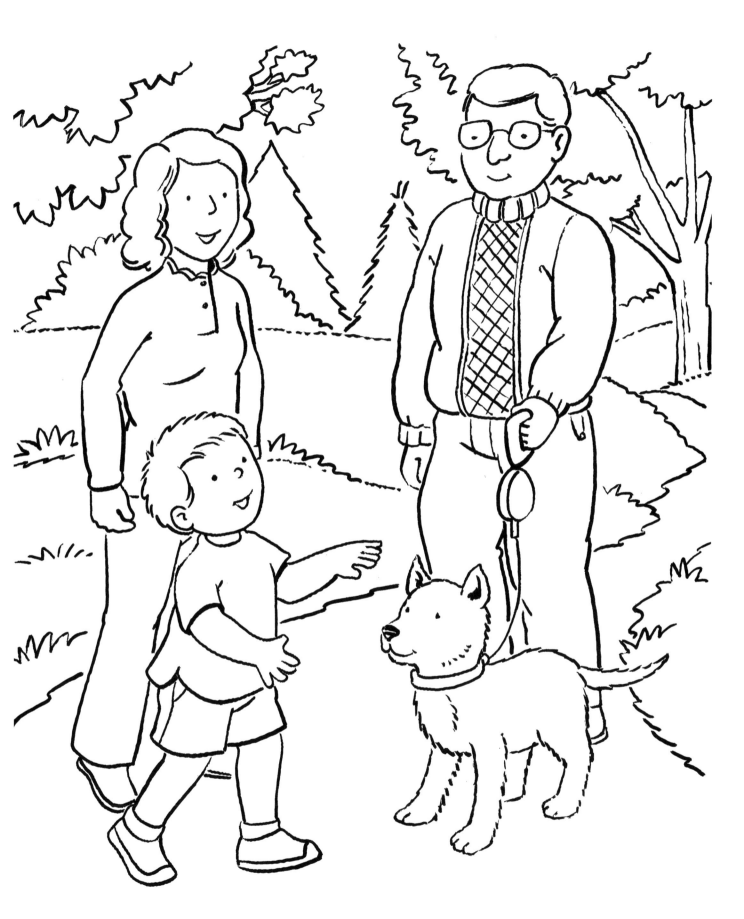

Do not pet a strange dog unless the owner says it's OK.
Even a friendly dog can be dangerous.

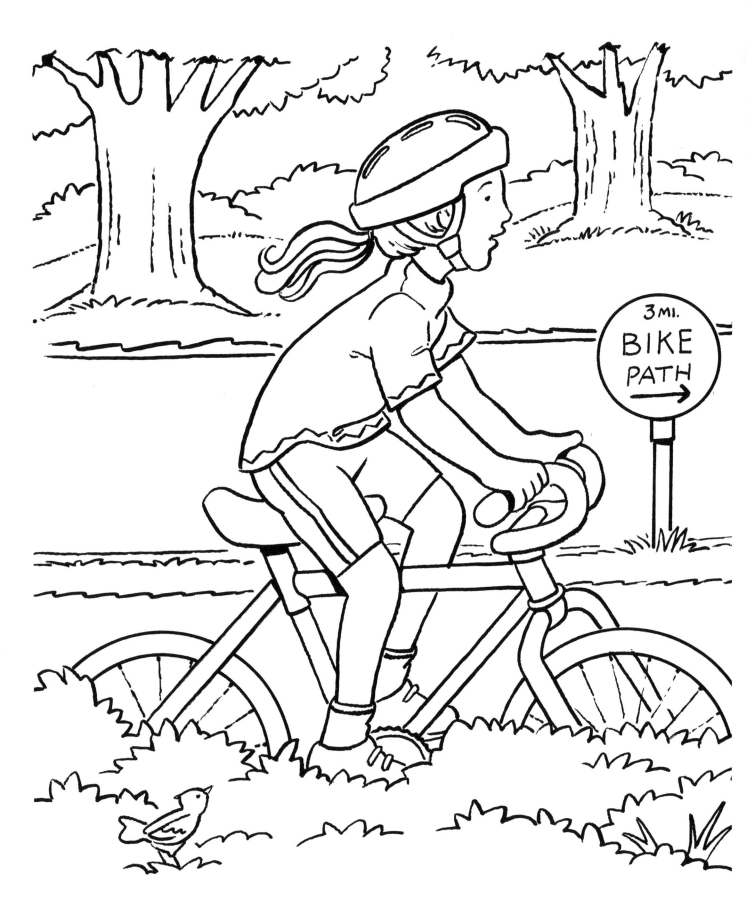

Always wear a helmet when you ride your bike.

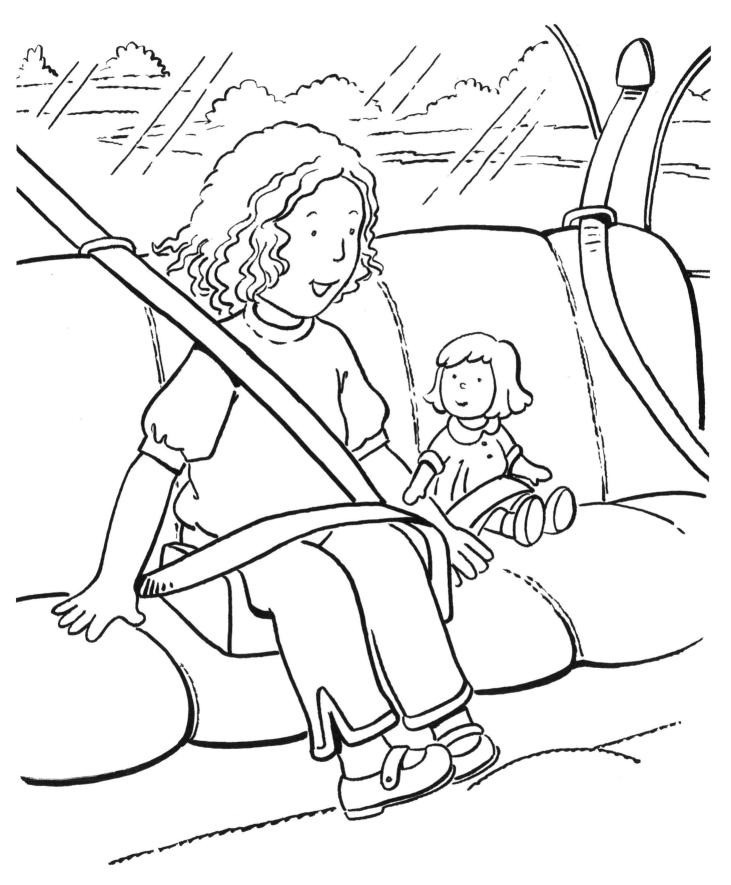

Always buckle your seat belt when riding in the car.
Always!—even if you're not going far.

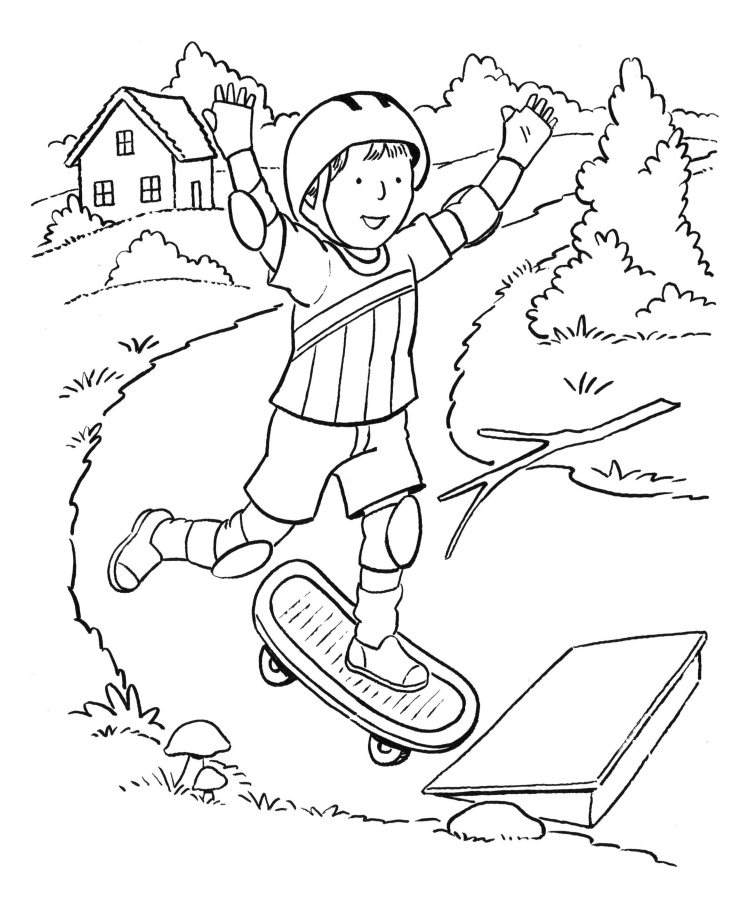

Always wear kneepads and elbow pads
when you ride on a skateboard.

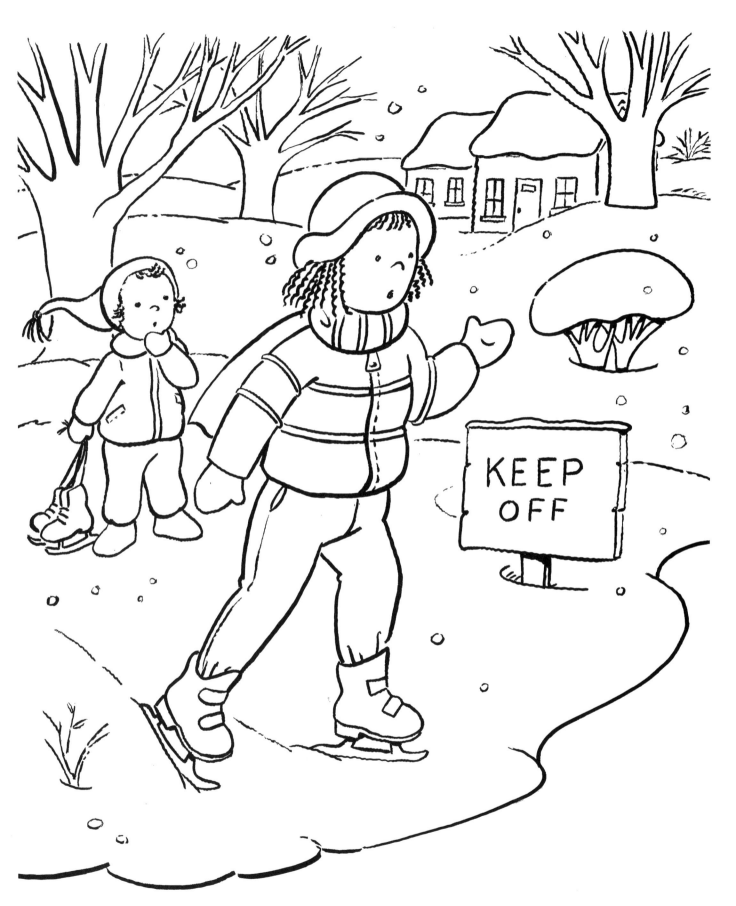

Always pay attention to signs and do what they say.
Never skate on thin ice!

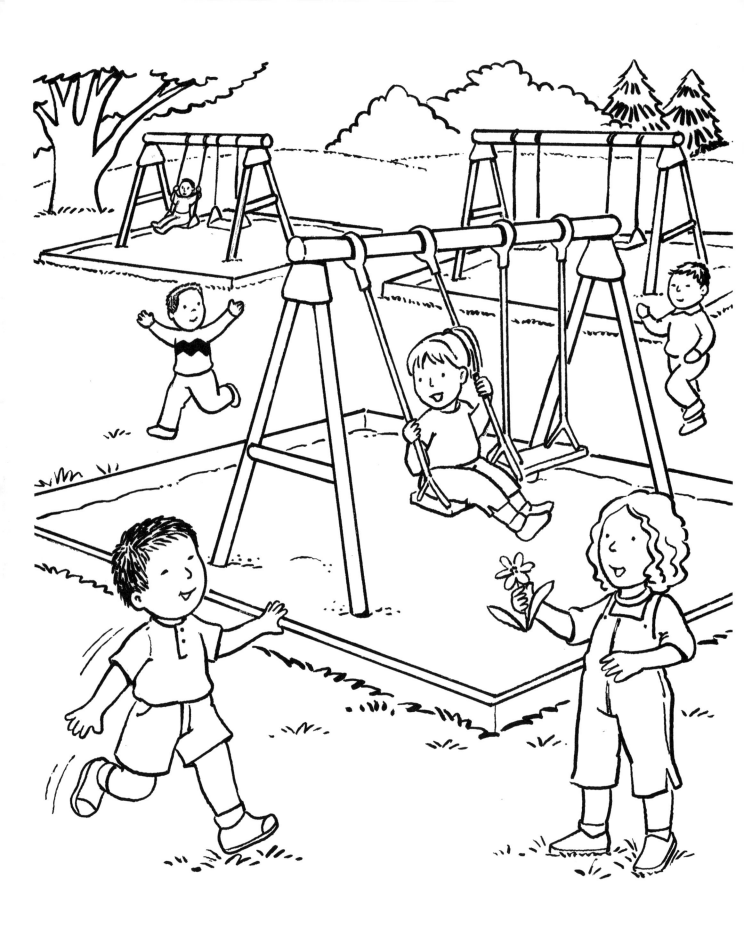

Always obey the playground rules. They were made to keep you safe. Stay clear of the swings.

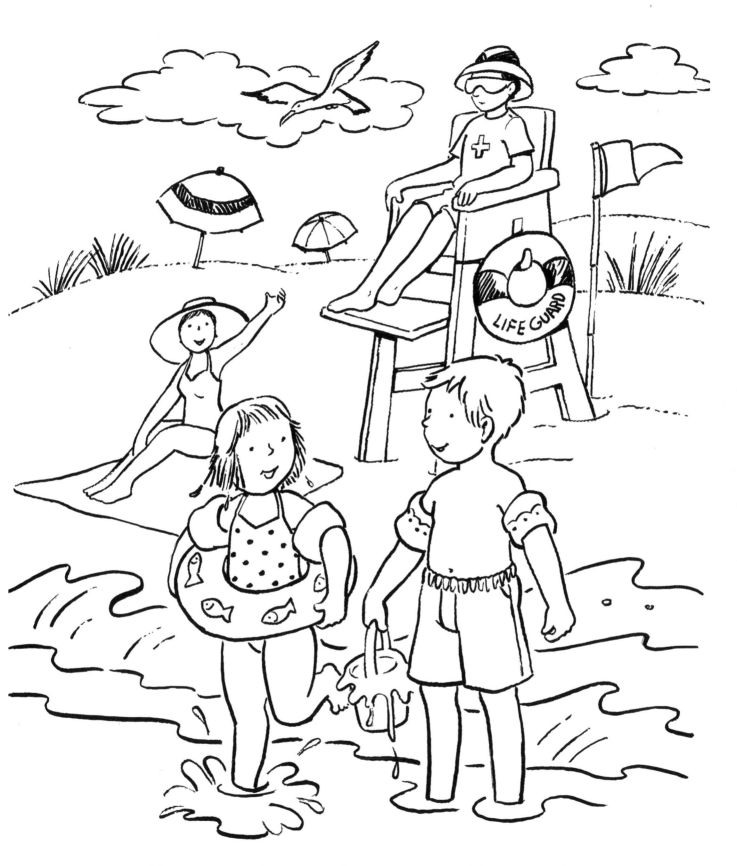

Always swim or play near a lifeguard.
Never swim alone—always swim with a friend.

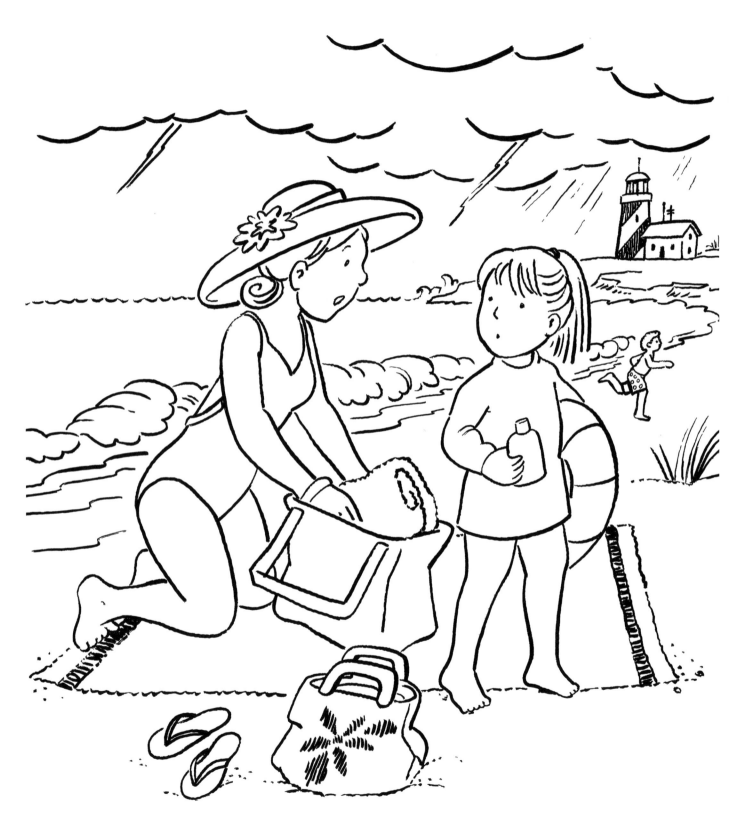

Leave the beach right away if you hear thunder.

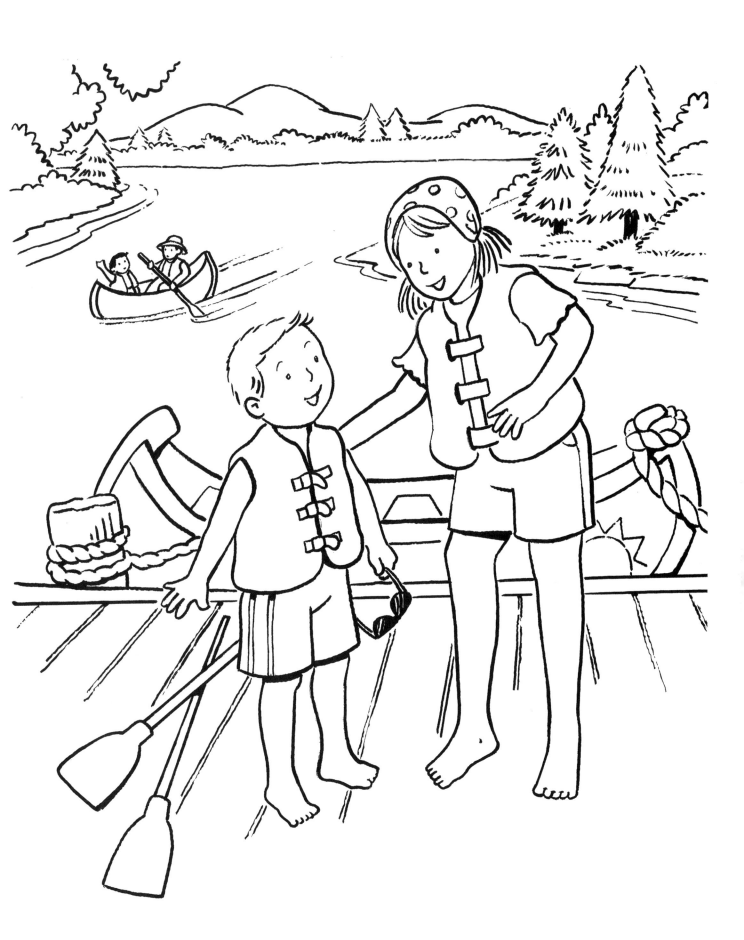

Always wear a life jacket if you go on a boat.

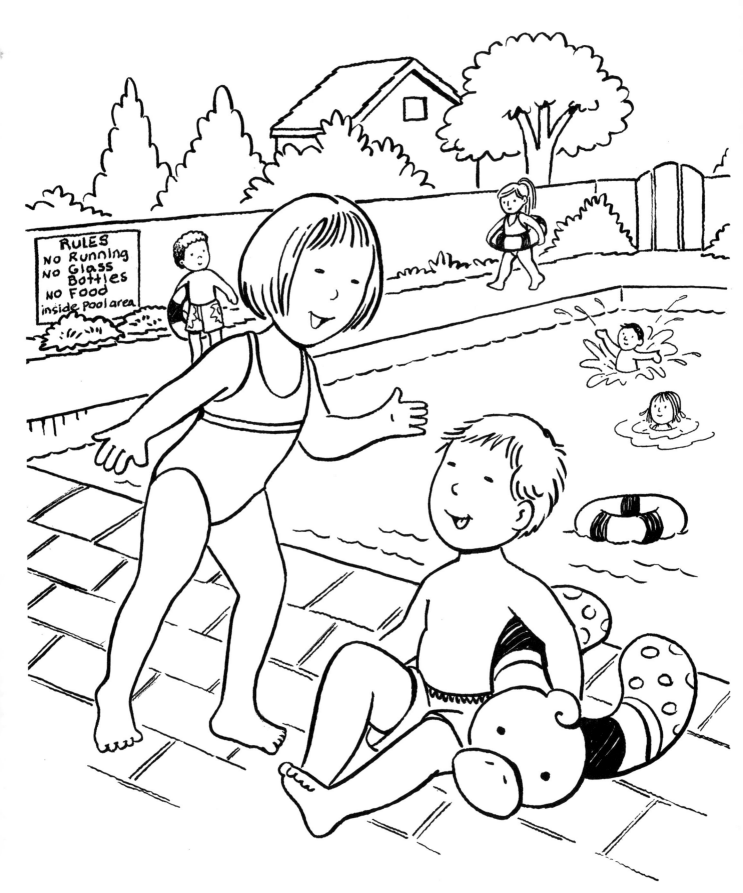

Always walk—never run—in a swimming pool area.
Swimming pool rules help you have fun and stay safe!